The
CAT
Yearbook

First published in Great Britain in 2009 by

Quercus
21 Bloomsbury Square
London
WC1A 2NS

A CIP catalogue record for this book is available from the British Library

ISBN 978 1 84866 023 6

Printed and bound in China

10 9 8 7 6 5 4 3 2 1

Layout, picture research and authoring by Pikaia Imaging

The
CAT
Yearbook

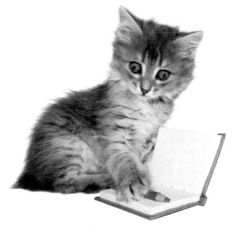

Quercus

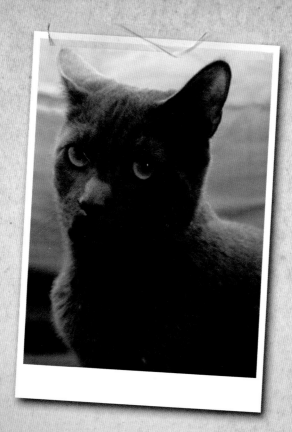

NAME: *Celia*

MY BEST TEACHER: *Mr Catt*

SCHOOL CLUB: *Cheerleading*

WHAT I WANT TO BE: *A model — I was born for the catwalk!*

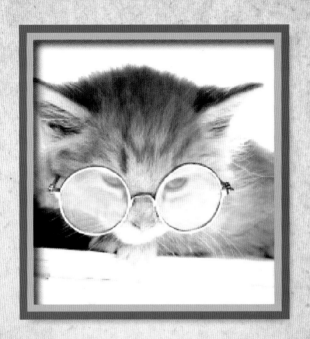

NAME: *Loretta*

MY BEST TEACHER: *Mr Tom*

SCHOOL CLUB: *Wrestling*

WHAT I WANT TO BE: *Antiquarian bookseller —*
I've always preferred bookworms to ringworm!

NAME: *Papillon*

MY BEST TEACHER: *Mrs Shawshank*

SCHOOL CLUB: *Metalwork*

WHAT I WANT TO BE: *Out on parole by the time I graduate*

NAME: *Tubbs*

MY BEST TEACHER: *Mr Emeril*

SCHOOL CLUB: *Cookery*

WHAT I WANT TO BE: *Food taster at a chicken ranch*

NAME: *Shadow*

MY BEST TEACHER: *Mr Lee*

SCHOOL CLUB: *Stealth and concealment*

WHAT I WANT TO BE: *A ninja or, failing that, an IRS inspector*

NAME: Washington

MY BEST TEACHER: Mr Payne

SCHOOL CLUB: Debating society

WHAT I WANT TO BE: The First Cat, so I can sleep in the corner of the Oval Office

NAME: *Luigi*

MY BEST TEACHER: *Mr Fettuccine*

SCHOOL CLUB: *Italian*

WHAT I WANT TO BE: *A pasta chef, justa lika ma dear Mama!*

NAME: *Hemingway*

MY BEST TEACHER: *Mrs Hunter*

SCHOOL CLUB: *Outdoor pursuits*

WHAT I WANT TO BE: *A pest-control operative —
think of the freebies...*

NAME: *Snowy*

MY BEST TEACHER: *Mr Peary*

SCHOOL CLUB: *Sledging*

WHAT I WANT TO BE: *An Arctic explorer — with a coat like mine I was born for the job!*

NAME: *Woody*

MY BEST TEACHER: *Mrs Larch*

SCHOOL CLUB: *Climbing*

WHAT I WANT TO BE: *A tree surgeon – though it has its ups and downs...*

NAME: *Crackers*

MY BEST TEACHER: *Mr Moriarty*

SCHOOL CLUB: *Gymnastics*

WHAT I WANT TO BE: *A cat burglar — you just can't keep me out!*

NAME: *Clementine*

MY BEST TEACHER: *Mr Panhandle*

SCHOOL CLUB: *Mineralogy*

WHAT I WANT TO BE: *A mine inspector — if it shines... it's mine!*

NAME: *Champion*

MY BEST TEACHER: *Mr Ed*

SCHOOL CLUB: *Horseriding*

WHAT I WANT TO BE: *A horse whisperer —*
I want to be in a stable relationship!

NAME: *Beethoven*

MY BEST TEACHER: *Mr Vivaldi*

SCHOOL CLUB: *Music*

WHAT I WANT TO BE: *A concert pianist —
everyone loves a kitten on the keys!*

NAME: *Bluebell*

MY BEST TEACHER: *Mr Shovel*

SCHOOL CLUB: *Gardening*

WHAT I WANT TO BE: *A landscape gardener —*
I just love digging in the dirt!

NAME: *James*

MY BEST TEACHER: *Ms Moneypenny*

SCHOOL CLUB: *I could tell you, but then I'd have to kill you*

WHAT I WANT TO BE: *Secret agent*

NAME: *Petra*

MY BEST TEACHER: *Dr Dolittle*

SCHOOL CLUB: *Zoology*

WHAT I WANT TO BE: *A veterinarian — but I promise I won't bring my work home with me!*

NAME: *Jean-Paul*

MY BEST TEACHER: *Mrs Nietzsche*

SCHOOL CLUB: *Philosophy*

WHAT I WANT TO BE: *Who can say? The future itself is merely a metaphysical construct within which the juxtaposition of self and desire are... etc etc etc.*

NAME: *Lightning*

MY BEST TEACHER: *Mr Napper*

SCHOOL CLUB: *Meditation*

WHAT I WANT TO BE: *Quality control tester in a mattress factory*

NAME: *Rudolf*

MY BEST TEACHER: *Mr Kringle*

SCHOOL CLUB: *Rapping*

WHAT I WANT TO BE: *A department store Santa —
have you been good this year?*

NAME: *Bono*

MY BEST TEACHER: *Mr Gore*

SCHOOL CLUB: *Nature studies*

WHAT I WANT TO BE: *An eco-warrior.*
My planet needs me!

NAME: *Magnum*

MY BEST TEACHER: *Mr Rockford*

SCHOOL CLUB: *Photography*

WHAT I WANT TO BE: *A private detective —*
I like keeping an eye on people...

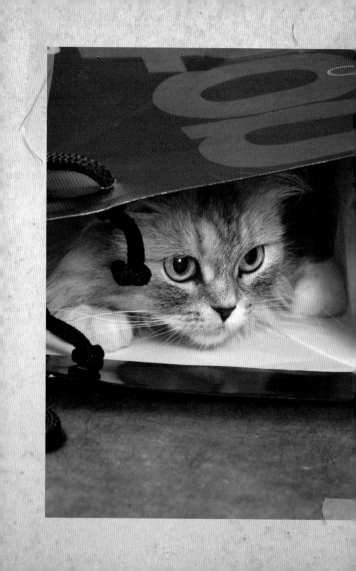

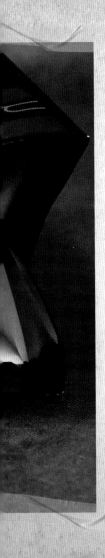

NAME: *Paris*

MY BEST TEACHER: *Ms Trump*

SCHOOL CLUB: *Economics*

WHAT I WANT TO BE:
A shopaholic or, failing that,

something in retail

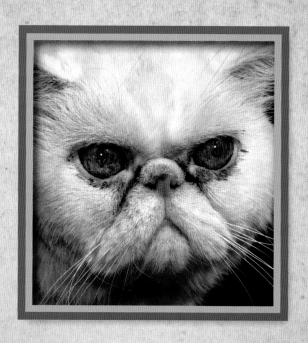

NAME: *Cliff*

MY BEST TEACHER: *Dr Spin*

SCHOOL CLUB: *Media studies*

WHAT I WANT TO BE: *An image consultant.*
Because first impressions count!

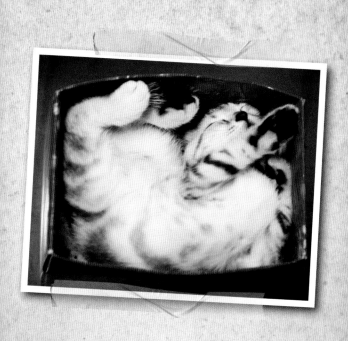

NAME: *Phil*

MY BEST TEACHER: *Mr File*

SCHOOL CLUB: *Space planning*

WHAT I WANT TO BE: *Specialist in ergonomics —
I'm fed up with being a waste of space!*

NAME: *Bullet*

MY BEST TEACHER:

Mr McQueen

SCHOOL CLUB: *Auto repair*

WHAT I WANT TO BE: *I want
to put my foot down and
escape for the weekend*

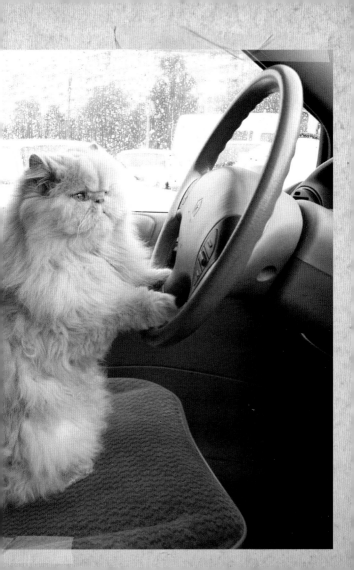

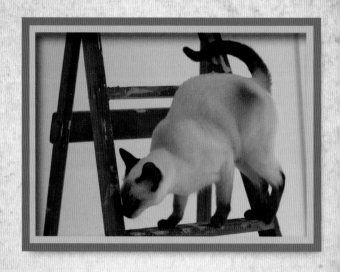

NAME: *Sukie*

MY BEST TEACHER: *Ms Stewart*

SCHOOL CLUB: *Chess*

WHAT I WANT TO BE: *A painter and decorator — I always carry a paintbrush!*

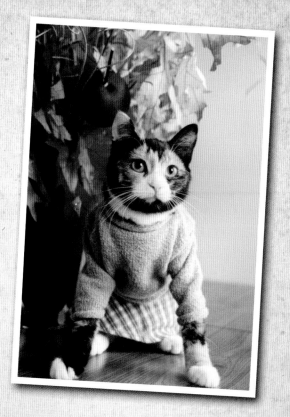

NAME: *Woolly*

MY BEST TEACHER: *Mr Benetton*

SCHOOL CLUB: *Knitting*

WHAT I WANT TO BE: *I don't care so long as I'm warm...*

NAME: *Vidal*

MY BEST TEACHER: *Mr Scissorhands*

SCHOOL CLUB: *None, but I hang out with guinea pigs so I don't feel out of place*

WHAT I WANT TO BE: *Hairdresser — I have so little of my own that I can't resist playing with other people's!*

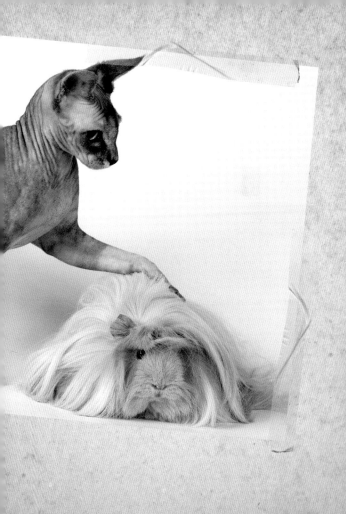

NAME: *Carrie*

MY BEST TEACHER: *Mr Blahnik*

SCHOOL CLUB: *Shopping*

WHAT I WANT TO BE: *Assistant in a Manhattan boutique, with free loan of the shoes after the store closes!*

Name: *Mitch*

My Best Teacher: *Mr Hasselhoff*

School Club: *Swimming (theory only)*

What I want to be: *Lifeguard at a paddling pool. But don't expect me to get my feet wet!*

NAME: *Willow*

MY BEST TEACHER: *Mr Giles*

SCHOOL CLUB: *Literature*

WHAT I WANT TO BE: *A librarian — I love to get my head stuck into a good book*

NAME: *Howard*

MY BEST TEACHER: *Mr Hughes*

SCHOOL CLUB: *Cleanliness*

WHAT I WANT TO BE: *Indoors, safe and clean*

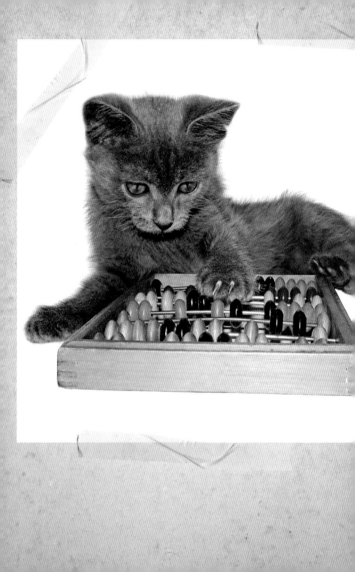

NAME: *Marty*

MY BEST TEACHER:
Mr Greenspan

SCHOOL CLUB:
Mathematics

WHAT I WANT TO BE: *An accountant — did you think I used this abacus as a toy?*

NAME: *Blondin*

MY BEST TEACHER: *Mr Blaine*

SCHOOL CLUB: *Acrobatics*

WHAT I WANT TO BE: *A high-wire walker — just to drive the local dogs crazy!*

NAME: *Jake*

MY BEST TEACHER: *Everything I need to know, I learn from the TV*

SCHOOL CLUB: *Media studies*

WHAT I WANT TO BE: *A couch potato*

NAME: *Captain Jack*

MY BEST TEACHER: *Mr Yellowbeard*

SCHOOL CLUB: *Navigation*

WHAT I WANT TO BE: *A pirate's cat —
just let me sleep on the treasure chest, you
scurvy dogs!*

NAME: *Coco*

MY BEST TEACHER: *Mr Barnum*

SCHOOL CLUB: *Circus arts*

WHAT I WANT TO BE: *A children's entertainer —
I've got a hat but the red nose won't stay on...*

NAME: *Audrey*

MY BEST TEACHER: *Miss Jones*

SCHOOL CLUB: *Shorthand*

WHAT I WANT TO BE: *A top crime reporter — I'll make you spill the beans!*

NAME: *Chopstick*

MY BEST TEACHER: *Mr Li*

SCHOOL CLUB: *Oriental cookery*

WHAT I WANT TO BE: *Chef at a Chinese take-out*
— provided I get to eat the leftovers...

NAME: *Cliff*

MY BEST TEACHER: *Mr Klaven*

SCHOOL CLUB: *Philately*

WHAT I WANT TO BE: *A postman in the proud US mail service*

NAME: *Molly*

MY BEST TEACHER: *Mrs W. Mart*

SCHOOL CLUB: *Trolley management*

WHAT I WANT TO BE: *Supermarket clerk —
but only if I get to stack the catfood aisle...*

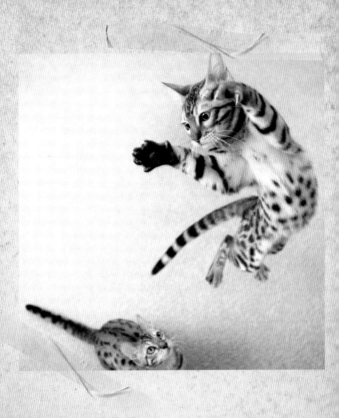

NAMES: Shaquille and Kobe

OUR BEST TEACHER: Mrs Calhoun

SCHOOL CLUB: Basketball

WHAT WE WANT TO BE: Major league stars — we've got serious skills!

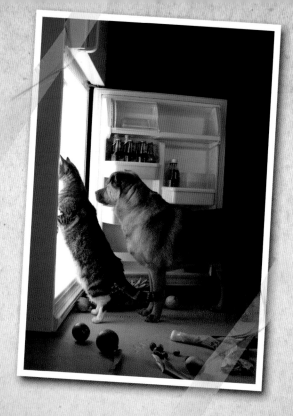

NAME: *The Phantom plus friend*

MY BEST TEACHER: *Mr Raffles*

SCHOOL CLUB: *Locksmithing*

WHAT I WANT TO BE: *A safecracker —*
I specialize in fridges

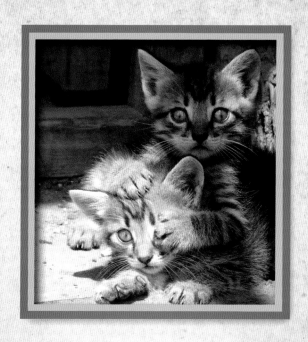

NAMES: *Shakey and Wobble*

OUR BEST TEACHER: *Mr Hays*

SCHOOL CLUB: *Moral fortitude*

WHAT WE WANT TO BE: *Film censors – not sure we can handle the horror films though...*

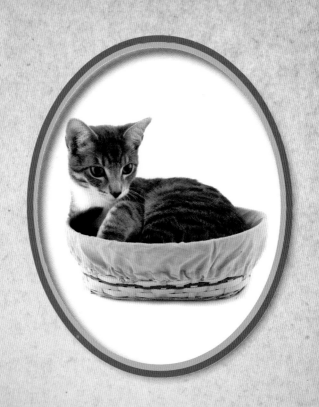

NAME: *Simon*

MY BEST TEACHER: *Mr Ramsey*

SCHOOL CLUB: *Cookery*

WHAT I WANT TO BE: *Pie taster — I've always been a bit of a dish*

NAME: *Sting*

MY BEST TEACHER: *Mr Gaia*

SCHOOL CLUB: *Eco-studies*

WHAT I WANT TO BE: *An environmentalist — I just love tree-hugging*

NAME: *The Black Cat Group*

OUR BEST TEACHER: *Mr Marceau*

SCHOOL CLUB: *Theatre studies*

WHAT WE WANT TO BE: *An experimental mime group — we are well co-ordinated*

NAME: *Frobisher*

MY BEST TEACHER: *Mr Fogg*

SCHOOL CLUB: *Travel*

WHAT I WANT TO BE: *A hotel reviewer — I'll need that five-star treatment!*

NAME: *Harry*

MY BEST TEACHER: *Mr Potter*

SCHOOL CLUB: *Magic*

WHAT I WANT TO BE: *I already know I'm a wizard — I just need a hat and a cape...*

NAME: *Fang*

MY BEST TEACHER:
Miss Floss

SCHOOL CLUB:
Personal hygiene

WHAT I WANT TO BE:

*A dental hygienist — I'm
very good at flossing away
the evidence*

NAME: *Blanche*

MY BEST TEACHER: *Mrs White*

SCHOOL CLUB: *Housekeeping*

WHAT I WANT TO BE: *A laundress — if there's one thing I can't stand it's dirty bedding*

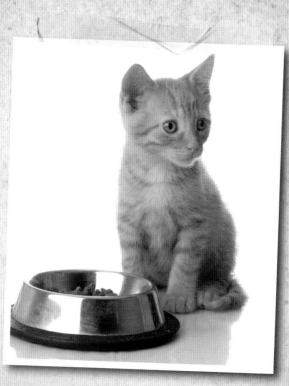

NAME: *Ginger*

MY BEST TEACHER: *Mrs Stewart*

SCHOOL CLUB: *Food sciences*

WHAT I WANT TO BE: *Quality control specialist.*
This would be rejected for a start!

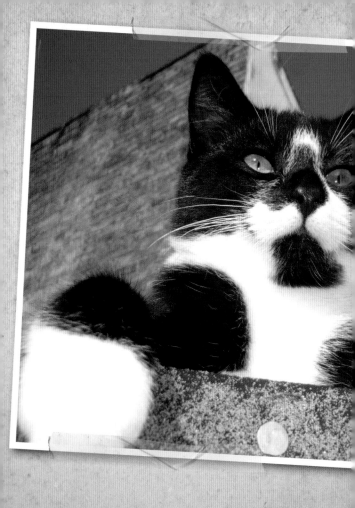

NAME: *BB*

MY BEST TEACHER:
Mr Orwell

SCHOOL CLUB:
Crowd management

WHAT I WANT TO BE:

*In charge. You are
either with me or
against me,
so watch out!*

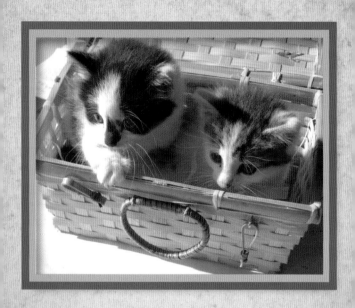

NAMES: *Bill and Ben*

OUR BEST TEACHER: *Mr Samsonite*

SCHOOL CLUB: *Product design*

WHAT WE WANT TO BE: *Luggage wholesalers —
I really think we are going somewhere!*

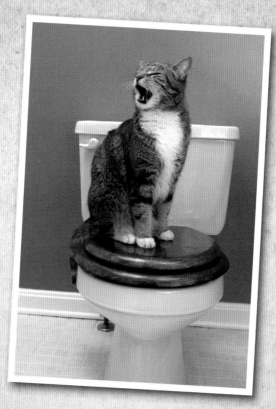

NAME: *John*

MY BEST TEACHER: *Mrs Fig*

SCHOOL CLUB: *Fruit preservation*

WHAT I WANT TO BE: *I'll tell you as soon as I can work out how to get the seat up!*

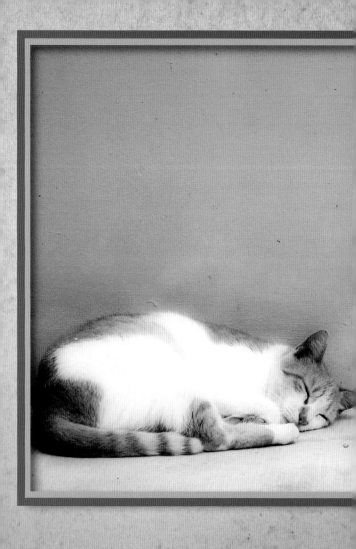

NAME: *Rothko*

MY BEST TEACHER:
Mrs Pollock

SCHOOL CLUB:
Home improvement

WHAT I WANT TO BE:

*An interior designer —
these colours are very
restful don't
you... zzzzzzzz*

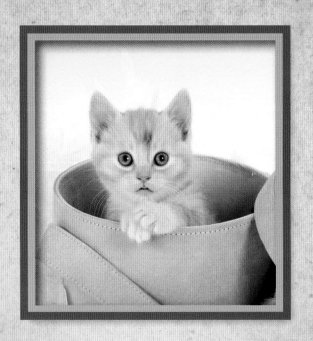

NAME: *Harry*

MY BEST TEACHER: *Mr Houdini*

SCHOOL CLUB: *Entertaining*

WHAT I WANT TO BE: *An escapologist. I'm great at thinking out of the box!*

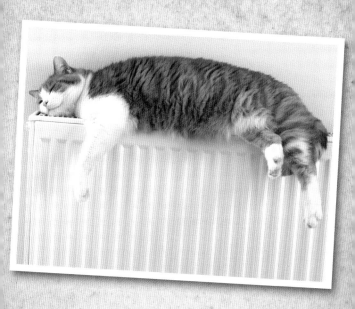

NAME: *Pete*

MY BEST TEACHER: *Mrs Combi*

SCHOOL CLUB: *Fuel conservation*

WHAT I WANT TO BE: *A heating engineer. Frankly,
I could make this a tad hotter!*

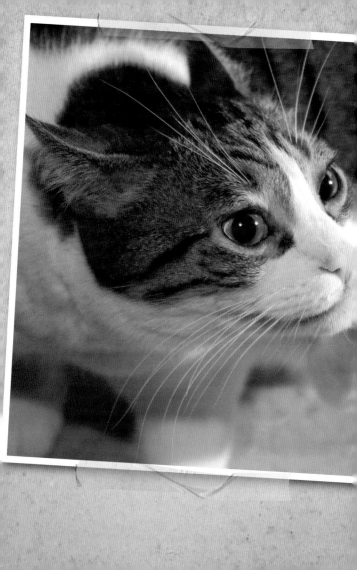

NAME: *Gribbly*

MY BEST TEACHER:
Mr Comb

SCHOOL CLUB:
Male grooming

WHAT I WANT TO BE:
*Flea researcher. I'm itching
to leave this place and get
on with it!*

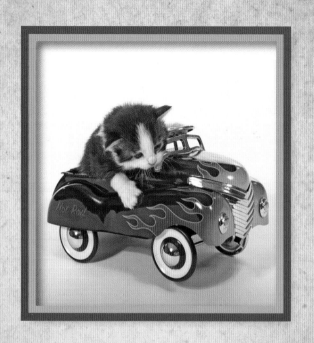

NAME: *Flash*

MY BEST TEACHER: *Mrs Michelin*

SCHOOL CLUB: *Auto skills*

WHAT I WANT TO BE: *A racing driver — I'm in the fast lane, baby!*

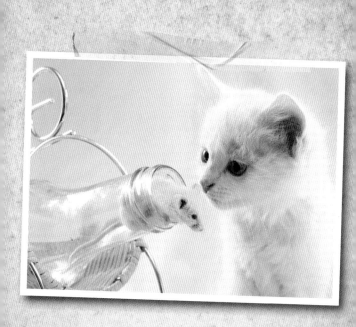

NAME: *Magoo*

MY BEST TEACHER: *Mr M. Mouse*

SCHOOL CLUB: *Prey recognition*

WHAT I WANT TO BE: *I haven't seen anything I want to do yet...*

NAME: *Duggie*

MY BEST TEACHER: *Mrs Swan*

SCHOOL CLUB: *Drama*

WHAT I WANT TO BE: *An actor. I am a natural —*
I have to play dead a lot at home!

NAME: *Ziggy*

MY BEST TEACHER: *Mr Bowie*

SCHOOL CLUB: *1970s studies*

WHAT I WANT TO BE: *A glam rock star. I've got the looks, haven't I?*

NAME: *Livingstone*

MY BEST TEACHER: *Mr Stanley*

SCHOOL CLUB: *Orienteering*

WHAT I WANT TO BE: *An explorer — I want to find the source of the cat food*

NAME: *Birdy*

MY BEST TEACHER: *Mr Zenda*

SCHOOL CLUB: *Bird watching*

WHAT I WANT TO BE: *I'd like to run my own aviary — though stocktaking may be an issue...*

NAME: *Sooty*

MY BEST TEACHER: *Mrs Coal*

SCHOOL CLUB: *Mining skills*

WHAT I WANT TO BE: *I'd like to do some digging – but not for a while as I'm still a minor!*

NAME: *Hannibal*

MY BEST TEACHER: *Mr Nosferatu*

SCHOOL CLUB: *Scary movies*

WHAT I WANT TO BE: *A horror vampire — I'll make the hairs on your back stand on end!*

NAME: *Sniffy*

MY BEST TEACHER: *Mr Odour*

SCHOOL CLUB: *Food sourcing*

WHAT I WANT TO BE: *Olfactory detector — I could find a noodle in a haystack!*

NAME: *Tennessee*

MY BEST TEACHER: *Mrs Williams*

SCHOOL CLUB: *Climbing*

WHAT I WANT TO BE: *A roofing specialist — I could be the head of department...*

NAME: *La La*

MY BEST TEACHER: *Mr Freud*

SCHOOL CLUB: *Psychology*

WHAT I WANT TO BE: *A teapot. No, wait —
I am a teapot... Ping!*

NAME: *Baz*

MY BEST TEACHER:
Mr Knievel

SCHOOL CLUB:
Dangerous sports

WHAT I WANT TO BE:
Alive in the morning

NAME: *Romero*

MY BEST TEACHER: *Mr Slater*

SCHOOL CLUB: *Horror films*

WHAT I WANT TO BE: *A zombie. They are much more active than I am!*

NAME: *Buck*

MY BEST TEACHER: *Mr Star*

SCHOOL CLUB: *Coffee mornings*

WHAT I WANT TO BE: *I'd like to work in a coffee shop. I already drink a lot of espressos...*

NAME: *Clark*

MY BEST TEACHER: *Mrs Lane*

SCHOOL CLUB: *Comics*

WHAT I WANT TO BE: *A super hero... the flying is going to take a bit of practice though!*

NAME: *Jake*

MY BEST TEACHER: *Mr Cod*

SCHOOL CLUB: *Tropical fishing*

WHAT I WANT TO BE: *I want my own fishmongers — for obvious reasons!*

NAME: *Lucy*

MY BEST TEACHER: *Mrs Silk*

SCHOOL CLUB: *Clothes-making*

WHAT I WANT TO BE: *A fabric designer — but I can't promise I won't fall asleep on the job…*

NAME: *Fluff*

MY BEST TEACHER: *Mr Kiam*

SCHOOL CLUB: *Furballing*

WHAT I WANT TO BE: *I'd like to start a razor manufacturers — and then sell it*

NAME: *Leica*

MY BEST TEACHER: *Mr Red*

SCHOOL CLUB: *Nightlife*

WHAT I WANT TO BE: *I want to specialize in night-vision goggles*

NAME: *Ronaldo*

MY BEST TEACHER:
Mr Berlusconi

SCHOOL CLUB: *Italian*

WHAT I WANT TO BE:
I'm not sure — but I'm
completely caught up in
Venetian history

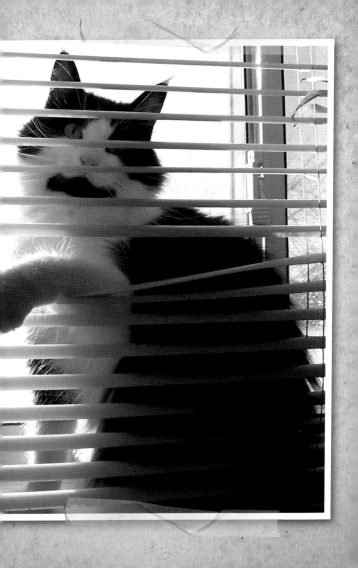

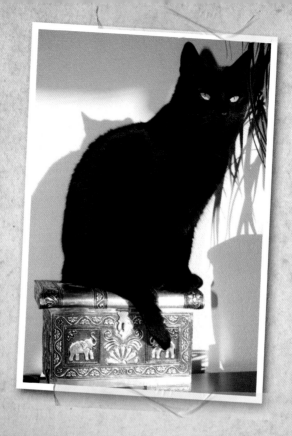

NAME: *Knuckles*

MY BEST TEACHER: *Mr Fu*

SCHOOL CLUB: *Martial arts*

WHAT I WANT TO BE: *A security guard —
nobody is going to grab my jewels!*

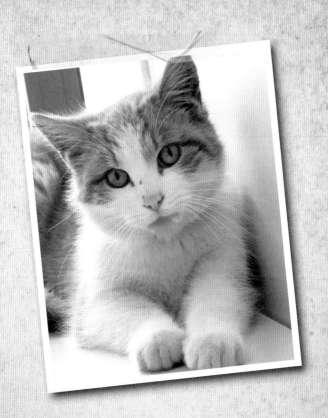

NAME: *Kitty*

MY BEST TEACHER: *Mr Harrison*

SCHOOL CLUB: *Photography*

WHAT I WANT TO BE: *Top fashion model —
what else? I'm clearly gorgeous!*

NAME: *Barney*

MY BEST TEACHER: *Mr Goody*

SCHOOL CLUB: *Paw—eye co-ordination*

WHAT I WANT TO BE: *I'd like to represent my country in the Olympic staring contest...*

NAME: *Rocky*

MY BEST TEACHER: *Mr De Niro*

SCHOOL CLUB: *Boxing*

WHAT I WANT TO BE: *Boxer. Ideally I'll not lose anymore of my ear though!*

NAME: *Marmalade*

MY BEST TEACHER:

Mr Hughes

SCHOOL CLUB: *Grooming*

WHAT I WANT TO BE: *Cleaner.
And that's not " a cleaner "
— I just want to be a lot
cleaner*

NAME: *Carl*

MY BEST TEACHER: *Mr Sagan*

SCHOOL CLUB: *Astronomy*

WHAT I WANT TO BE: *Astronomer. That way I can get my paws on a telescope and use it to watch the birds!*

NAME: *Lucky*

MY BEST TEACHER: *Mrs Charm*

SCHOOL CLUB: *Sport supporters club*

WHAT I WANT TO BE: *A team mascot —
after all, I was born "Lucky"!*

NAME: *Google*

MY BEST TEACHER: *Mr Yahoo*

SCHOOL CLUB: *Computing*

WHAT I WANT TO BE: *Something in computers —*
I spend every free moment on my laptop

NAME: *Kurtz*

MY BEST TEACHER: *Mr Brando*

SCHOOL CLUB: *War film society*

WHAT I WANT TO BE: *Special operations cat —
I like hunting in the flower bed*

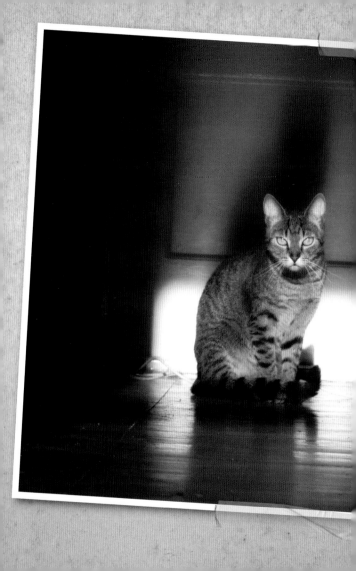

NAME: *Bond*

MY BEST TEACHER: *Q*

SCHOOL CLUB: *Espionage*

WHAT I WANT TO BE:

An undercover agent —
I can break into secret
bases (such as the
larder)

NAME: *Voltaire*

MY BEST TEACHER:
Mr Proust

SCHOOL CLUB: *Philosophy*

WHAT I WANT TO BE:
A thinker, a poet, a dreamer

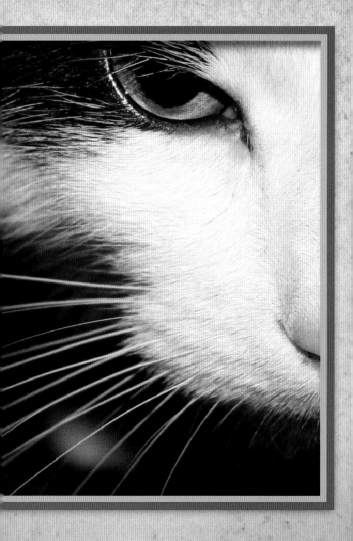

NAMES: *Mo, Larry and Curly*

OUR BEST TEACHER: *Mr Healy*

SCHOOL CLUB: *Comedy*

WHAT WE WANT TO BE: *A comedy trio.*
We can be very funny — if we can stay awake
long enough...

NAME: *Fang*

MY BEST TEACHER: *Mrs Molar*

SCHOOL CLUB: *Biting techniques*

WHAT I WANT TO BE: *Dental model. My teeth
are my best feature — get a look at these beauties!*

NAME: *Nemesis*

MY BEST TEACHER: *Mr Luther*

SCHOOL CLUB: *Mineralogy*

WHAT I WANT TO BE: *Evil genius. I've been eating kryptonite but it's not doing anything...*

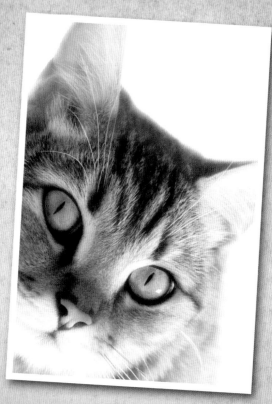

NAME: *Queenie*

MY BEST TEACHER: *Mr Rimmel*

SCHOOL CLUB: *Modelling*

WHAT I WANT TO BE: *A cover girl — because
I'm worth it ("it" being a plate of grilled chicken)*

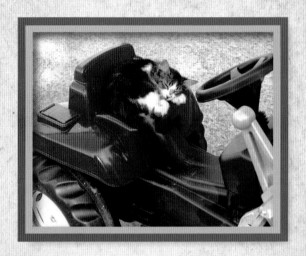

NAME: *Earl*

MY BEST TEACHER: *Mr Kellogg*

SCHOOL CLUB: *Tractor maintenance*

WHAT I WANT TO BE: *A farmer — I like the combine harvesters with comfy leather seats*

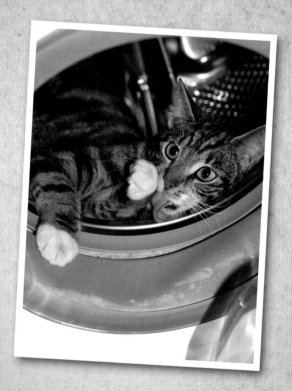

NAME: *Vince*

MY BEST TEACHER: *Mr Sudd*

SCHOOL CLUB: *Fabric management*

WHAT I WANT TO BE: *Washing machine test-driver... Want to come for a quick spin?*

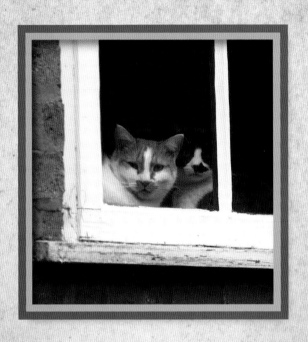

NAME: *Bruce*

MY BEST TEACHER: *Mr Willis*

SCHOOL CLUB: *People skills*

WHAT I WANT TO BE: *Hostage negotiator — if I can talk my way out of this place first...*

NAME: *Caruso*

MY BEST TEACHER: *Mr Pavarotti*

SCHOOL CLUB: *I'm in the choir*

WHAT I WANT TO BE:
*An opera singer. I perform
most nights!*

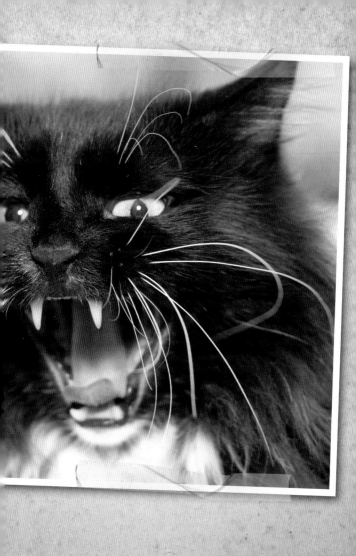

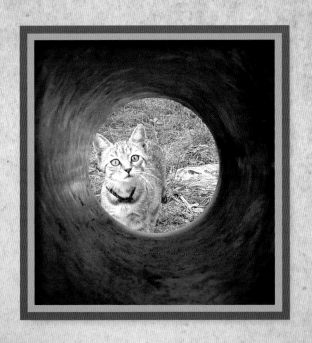

NAME: *Tubbs*

MY BEST TEACHER: *Mr Verne*

SCHOOL CLUB: *Potholing*

WHAT I WANT TO BE: *A tunnel excavator —
I'm looking into it at the moment*

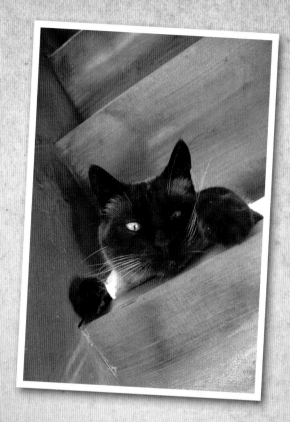

NAME: *Sven*

MY BEST TEACHER: *Mr Ikea*

SCHOOL CLUB: *Feng Shui*

WHAT I WANT TO BE: *An interior designer — you could put some storage under these stairs*

NAME: *Pod*

MY BEST TEACHER: *Mr Louis*

SCHOOL CLUB: *Whatever*

WHAT I WANT TO BE: *I dunno —*
I can't hold a job down anyway.
I keep getting the sack!

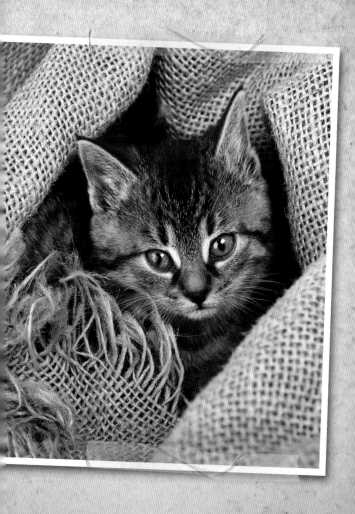

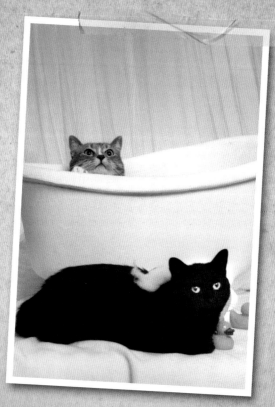

NAMES: *Dusty and Sooty*

OUR BEST TEACHER: *Mrs Bubbles*

SCHOOL CLUB: *We collect dirt, then wash it off*

WHAT WE WANT TO BE: *Something in the mining industry — we've already got carbon footprints!*

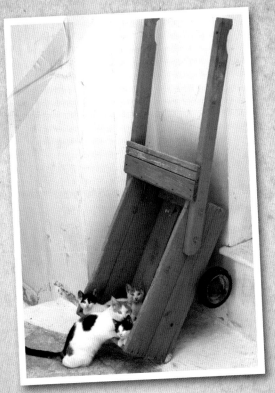

NAME: *Mum*

MY BEST TEACHER: *Supernanny*

SCHOOL CLUB: *No time for that*

WHAT I WANT TO BE: *Full-time mum. I've got one litter already and we're stuck in a mobile home...*

NAME: *George*

MY BEST TEACHER: *Mr Clarence Oddbody*

SCHOOL CLUB: *Life*

WHAT I WANT TO BE: *It's terrible — I have no idea... my future is staring me in the face!*

NAME: *Bill*

MY BEST TEACHER: *Mr Dell*

SCHOOL CLUB: *Web design*

WHAT I WANT TO BE: *I used to just stare out of windows, but now I wanna be a laptop cat*

NAME: *Dirk*

MY BEST TEACHER: *Mr Rizzo*

SCHOOL CLUB: *Anger management*

WHAT I WANT TO BE: *A pest controller — not sure I have the killer instinct though...*

NAME: *Birdie*

MY BEST TEACHER: *Mr Sparrow*

SCHOOL CLUB: *Ornithology*

WHAT I WANT TO BE: *A bit faster — they've all gone again, darn it!*

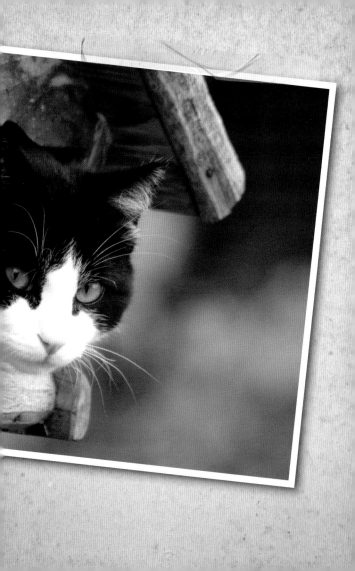

NAME: *Marilyn*

MY BEST TEACHER:

Mr Wilder

SCHOOL CLUB:

Health and beauty

WHAT I WANT TO BE:

A kept woman. I only purr for millionaires, daaarling...

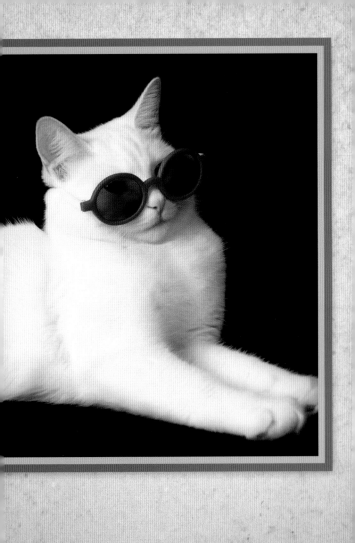

NAME: *Chelsea*

MY BEST TEACHER: *Mr Greenback*

SCHOOL CLUB: *Accessorizing*

WHAT I WANT TO BE: *Covered in jewels — being a princess is a full-time job!*

NAME: *Grizzly*

MY BEST TEACHER: *Mr Adams*

SCHOOL CLUB: *Scratching*

WHAT I WANT TO BE: *I'm already a white-collar worker... scratch me will ya, just a bit...*

NAME: *Kofi*

MY BEST TEACHER: *Mr Mandela*

SCHOOL CLUB: *Personal development*

WHAT I WANT TO BE: *I see myself in conflict resolution. Have you met my new pals?*

NAME: *Stewart*

MY BEST TEACHER: *Mrs Le Creuset*

SCHOOL CLUB: *Cooking*

WHAT I WANT TO BE: *Would love to have been a chef but it's all gone to pot...*

NAME: *Waldo*

MY BEST TEACHER: *Mrs Korbet*

SCHOOL CLUB: *Athletics*

WHAT I WANT TO BE: *A gymnast. But it's tough — they've got me jumping through hoops!*

NAME: *Jacques*

MY BEST TEACHER: *Mr Eiffel*

SCHOOL CLUB: *French*

WHAT I WANT TO BE: *Tour⸺ guide on the Eiffel Tower — they can pay ⸺ âté*

NAME: *Job*

MY BEST TEACHER: *Mr Mac*

SCHOOL CLUB: *Art and design*

WHAT I WANT TO BE: *Graphic designer — I'm gonna have to replace my mouse again though...*

NAME: *Baz*

MY BEST TEACHER:
I don't have any, man

SCHOOL CLUB:
School clubs are
for losers

WHAT I WANT TO BE:
Get off my back, man. I'm
too free to get a job —
I'm out all night partying!

NAME: *Ahab*

MY BEST TEACHER: *Mr Whale*

SCHOOL CLUB: *Angling*

WHAT I WANT TO BE: *A fisherman. Last fish I caught was this big!*

NAME: *Sinatra*

MY BEST TEACHER: *Mr Martin*

SCHOOL CLUB: *Crooning*

WHAT I WANT TO BE: *Not sure yet, but you can bet I'll do it my way when the time comes!*

NAME: *Prozac*

MY BEST TEACHER: *Mr Carnegie*

SCHOOL CLUB: *Positive thinking*

WHAT I WANT TO BE: *Whatever happens will be fine. Things are looking up...*

NAME: *Basher*

MY BEST TEACHER: *Mr Capone*

SCHOOL CLUB: *Protection*

WHAT I WANT TO BE: *Back on Monday for the full 20 grand... you get me?*

NAME: *Boeing*

MY BEST TEACHER: *Mr Wright and Mr Wright*

SCHOOL CLUB: *Model planes*

WHAT I WANT TO BE: *A pilot. Darn birds — if you can't beat 'em, join 'em!*

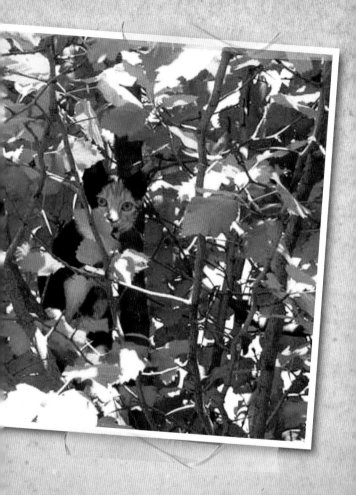

NAME: *Dali*

MY BEST TEACHER: *Mr Python*

SCHOOL CLUB: *Surrealism*

WHAT I WANT TO BE: *An absurd playwright —
most things I do are absurd already*

NAME: *Missy*

MY BEST TEACHER: *Nurse*

SCHOOL CLUB: *I'm too emotional for clubs*

WHAT I WANT TO BE: *A lot less weepy. It's all too much — I need to lie down...*

NAME: *Hugo*

MY BEST TEACHER: *Mr Irvin*

SCHOOL CLUB:

Wildlife photography

WHAT I WANT TO BE: *I want to be a wildlife filmmaker. Especially for the close-up shots of mice!*

NAME: *Snowy*

MY BEST TEACHER: *Mr Grumpy, Sneezy, Dopey etc.*

SCHOOL CLUB: *Mining*

WHAT I WANT TO BE: *Well, I just want life to be
a fairy tale really*

NAME: Hal

MY BEST TEACHER: Mr Garlick

SCHOOL CLUB: Speed dating

WHAT I WANT TO BE: I'd like to work in a
peppermint factory — the girls don't go for fish

NAME: *Tulip*

MY BEST TEACHER: *Miss Daisy*

SCHOOL CLUB: *Floral arranging*

WHAT I WANT TO BE: *A florist. I dig flowers — in fact, I dig them up rather a lot!*

NAME: *Hooper*

MY BEST TEACHER: *Life*

SCHOOL CLUB: *Clubs are for kids*

WHAT I WANT TO BE: *I'm a mature student — I just want to keep the grey matter ticking over*

NAME: *Animal*

MY BEST TEACHER: *Mr Douglas*

SCHOOL CLUB: *Self-defence*

WHAT I WANT TO BE: *A kickboxer. And if you don't like it, I'll tear ya to pieces, ya big girl!*

NAME: *Peaky*

MY BEST TEACHER: *Mr Everest*

SCHOOL CLUB: *Mountaineering*

WHAT I WANT TO BE: *Better at it than this — I just fell off the bookcase chasing a moth!*

NAME: *Pancake*

MY BEST TEACHER: *Mr Jones*

SCHOOL CLUB: *Whisker management*

WHAT I WANT TO BE: *Hairstylist. I need some tips on how to get this lot organized...*

NAME: *Tabasco*

MY BEST TEACHER: *Mr Jalapeno*

SCHOOL CLUB: *Food tasting*

WHAT I WANT TO BE: *Food taster. Though that's the last time I raid the bins at a Tex-Mex!*

NAME: *Gus*

MY BEST TEACHER:
Mr Kong

SCHOOL CLUB:
Anthropology

WHAT I WANT TO BE:
A jungle guerilla. I reckon I can blend in with the locals!

NAME: *Floyd*

MY BEST TEACHER: *Mr Brick*

SCHOOL CLUB: *Masonry*

WHAT I WANT TO BE: *A bricklayer. I'm always on top of my homework!*

NAME: *Archie*

MY BEST TEACHER: *Whoever rescues me*

SCHOOL CLUB: *Vet avoidance*

WHAT I WANT TO BE: *I want to be a long way away from this man with the thermometer...*

NAME: *Chopin*

MY BEST TEACHER: *Mrs Ivory*

SCHOOL CLUB: *Music*

WHAT I WANT TO BE: *A pianist — you hum it and I'll play it*

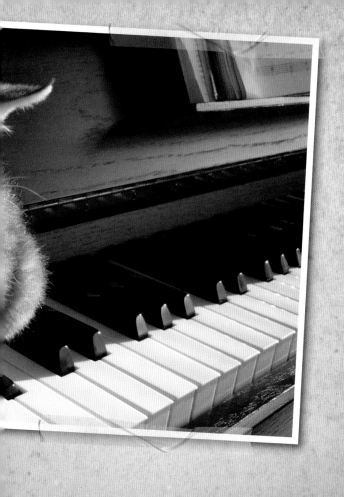

NAME: *Sid*

MY BEST TEACHER: *Mr Idol*

SCHOOL CLUB: *Guitar*

WHAT I WANT TO BE: *Punk rock star. I've got an attitude problem and the lyrics to go with it!*

NAME: *Gekko*

MY BEST TEACHER: *Mr Douglas*

SCHOOL CLUB: *Money management*

WHAT I WANT TO BE: *A city trader. Greed is good, and frankly I'm very greedy — especially for fish!*

NAME: *Buster*

MY BEST TEACHER: *Mr Chaplin*

SCHOOL CLUB: *Comedy*

WHAT I WANT TO BE: *I don't know — it's all so depressing. I wish I'd never been born...*

NAME: *Cosmo*

MY BEST TEACHER: *Mr Stein*

SCHOOL CLUB: *Home biology*

WHAT I WANT TO BE: *A genetic engineer — just like my father and his test tube before him*

NAME: *Helas*

MY BEST TEACHER: *Mrs Sunny*

SCHOOL CLUB: *Solar observation*

WHAT I WANT TO BE: *I'll tell you when the sun goes down — now go away!*